DesignOriginals

Creative Coloring
Flowers

Valentina Harper

Design
Originals

an Imprint of Fox Chapel Publishing
www.d-originals.com

Basic Color Ideas

In order to truly enjoy this coloring book, you must remember that there is no wrong way—or right way—to paint or use color. My drawings are created precisely so that you can enjoy the process no matter what method you choose to use to color them!

The most important thing to keep in mind is that each illustration was made to be enjoyed as you are coloring, to give you a period of relaxation and fun at the same time. Each picture is filled with details and forms that you can choose to color in many different ways. I value each person's individual creative process, so I want you to play and have fun with all of your favorite color combinations.

As you color, you can look at each illustration as a whole, or you can color each part as a separate piece that, when brought together, makes the image complete. That is why it is up to you to choose your own process, take your time, and, above all, enjoy your own way of doing things.

To the right are a few examples of ways that you can color each drawing.

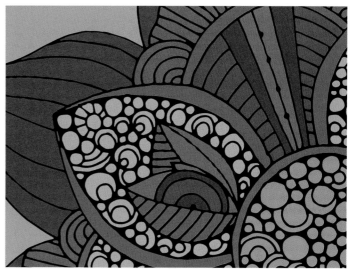

Color each section of the drawing (every general area, not every tiny shape) in one single color.

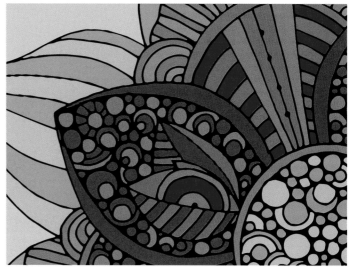

Within each section, color each detail (small shape) in alternating colors.

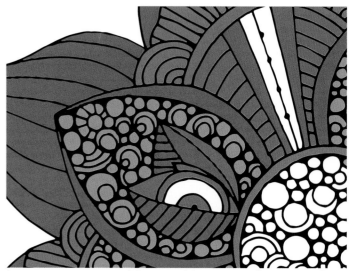

Leave some areas white to add a sense of space and lightness to the illustration.

Basic Color Tips

As an artist, I love to mix techniques, colors, and different mediums when it comes time to add color to my works of art. And when it comes to colors, the brighter the better! I feel that with color, illustrations take on a life of their own.

Remember: when it comes to painting and coloring, there are no rules. The most fun part is to play with color, relax, and enjoy the process and the beautiful finished result.

Feel free to mix and match colors and tones. Work your way from primary colors to secondary colors to tertiary colors, combining different tones to create all kinds of different effects. If you aren't familiar with color theory, below is a quick, easy guide to the basic colors and combinations you will be able to create.

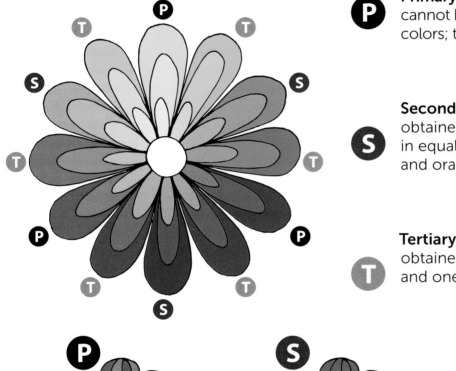

Primary colors: These are the colors that cannot be obtained by mixing any other colors; they are yellow, blue, and red.

Secondary colors: These colors are obtained by mixing two primary colors in equal parts; they are green, purple, and orange.

Tertiary colors: These colors are obtained by mixing one primary color and one secondary color.

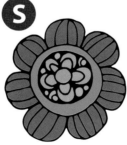

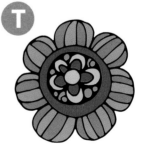

Don't be afraid of mixing colors and creating your own palettes.
Play with colors—the possibilities are endless!

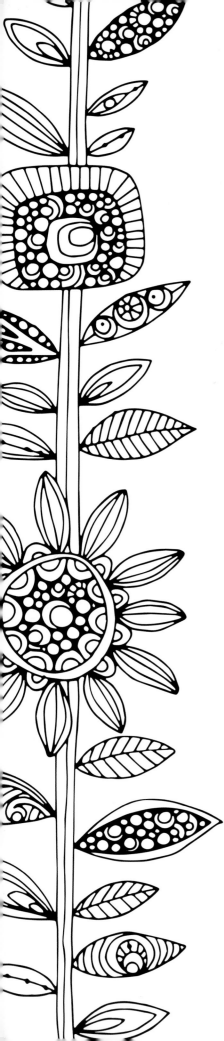

Color Inspiration

On the following eight pages, you'll see fully colored samples of my illustrations in this book, as interpreted by one talented artist and author, Marie Browning. I was delighted to invite Marie to color my work, and she used many different mediums to do so, all listed below each image. Take a look at how Marie decided to color the doodles, and find some inspiration for your own coloring! After the colored samples, the thirty delightful drawings just waiting for your color begin. Remember the tips I showed you earlier, think of the color inspiration you've seen, and choose your favorite medium to get started, whether it's pencil, marker, watercolor, or something else. Your time to color begins now, and only ends when you run out of pages! Have fun!

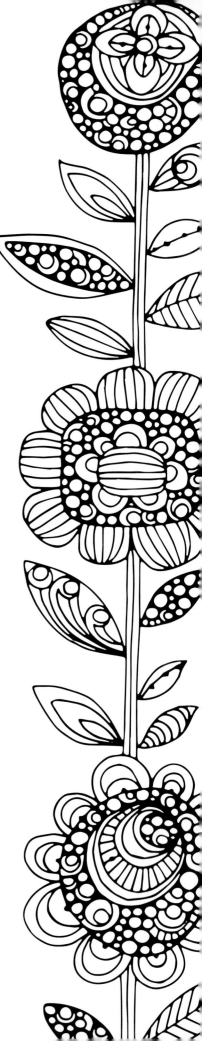

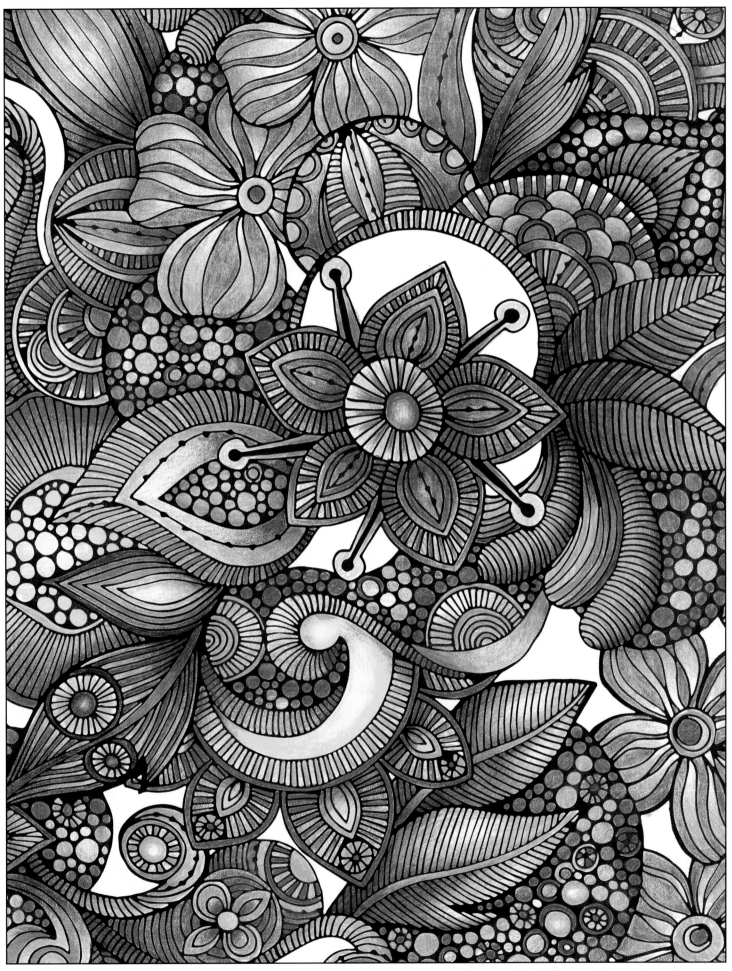

Irojiten Colored Pencils (Tombow). Vivid Tones. Color by Marie Browning.

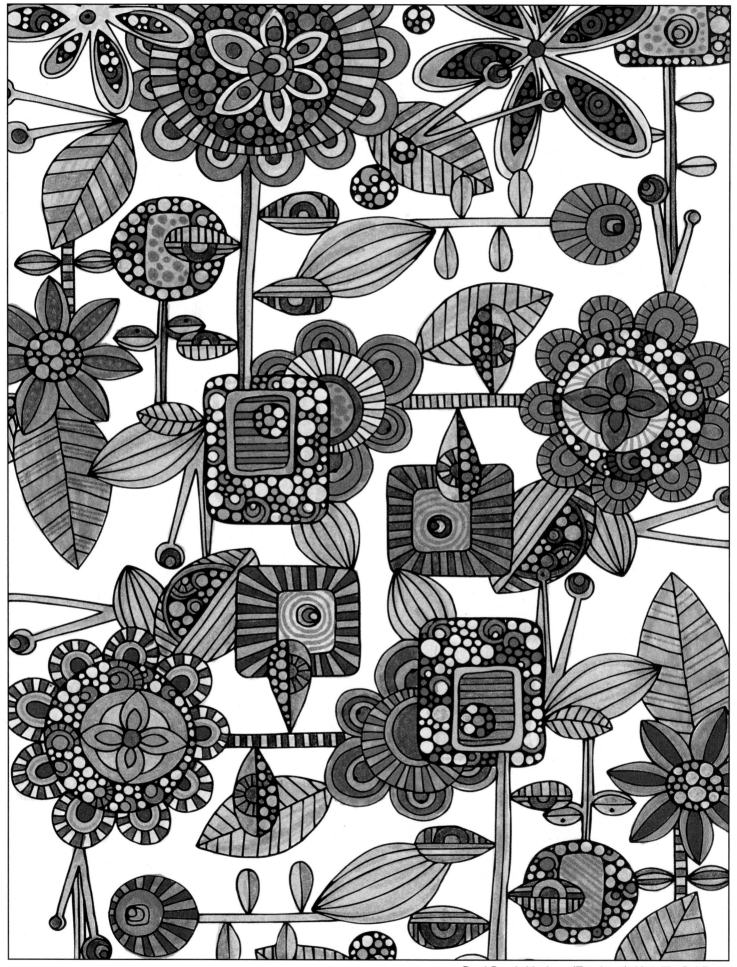

Dual Brush Markers (Tombow), Metallic Gel Pens
(Sakura). Jewel Tones. Color by Marie Browning.

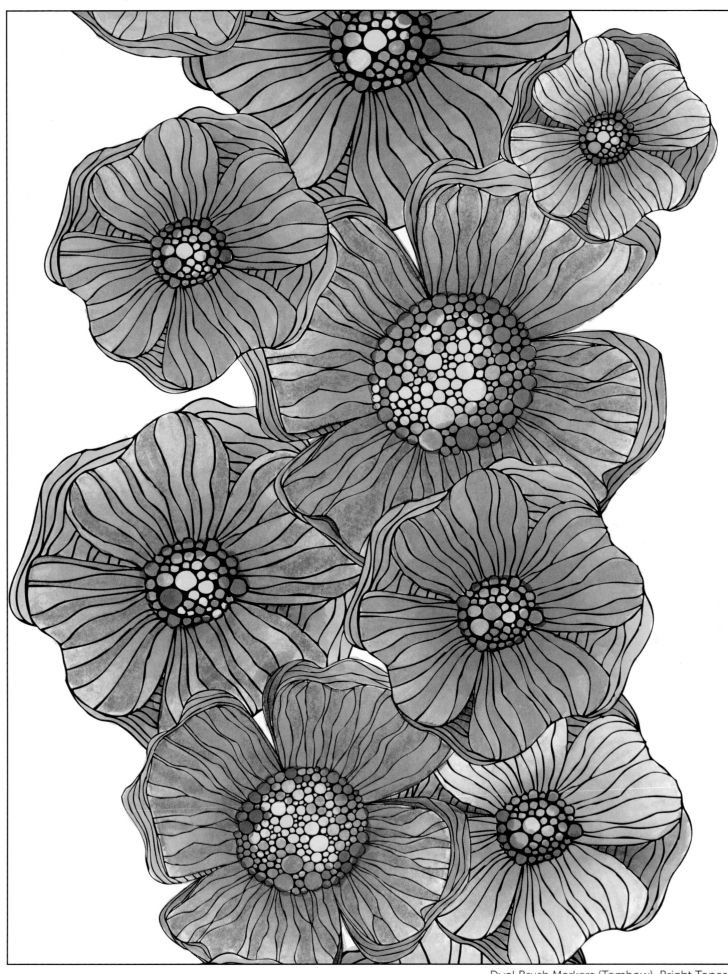

Dual Brush Markers (Tombow). Bright Tones.
Color by Marie Browning.

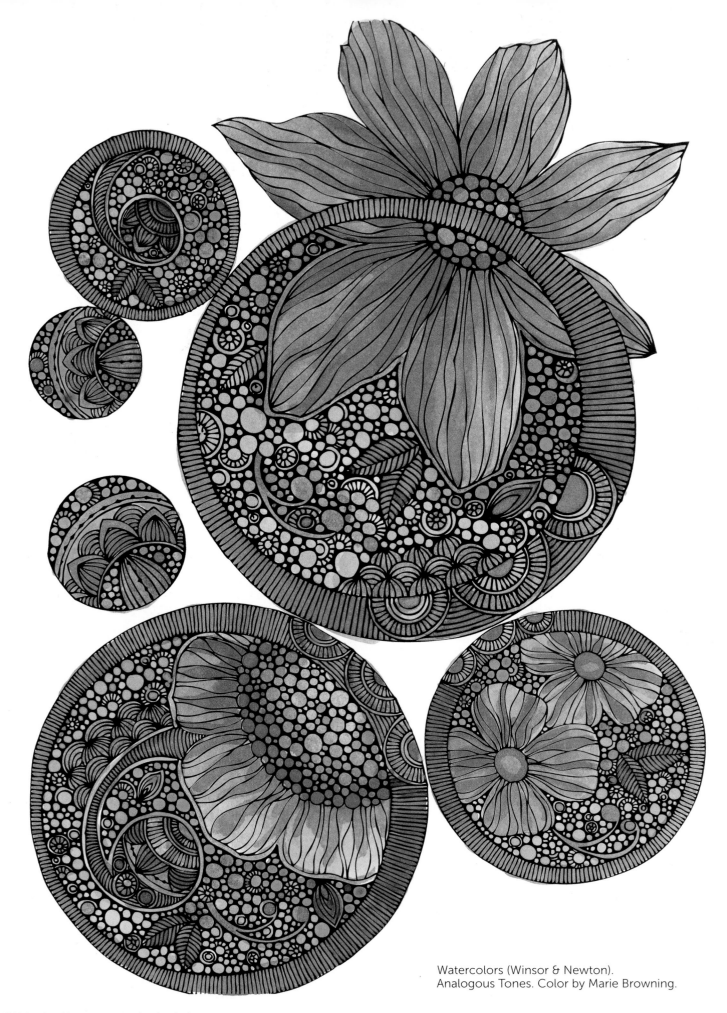

Watercolors (Winsor & Newton).
Analogous Tones. Color by Marie Browning.

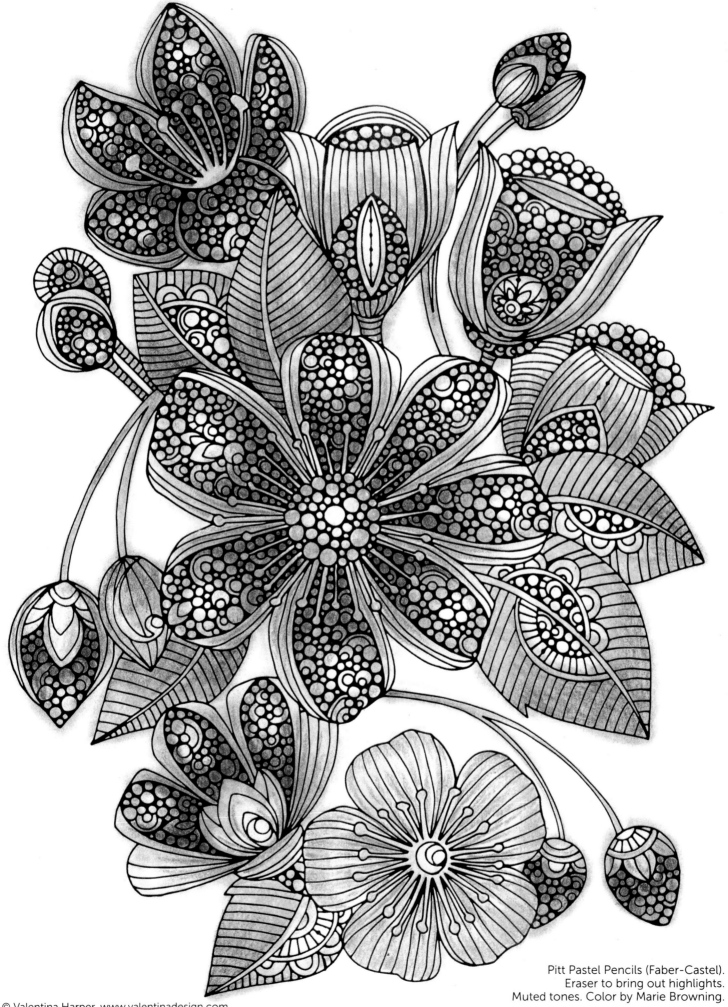

Pitt Pastel Pencils (Faber-Castel).
Eraser to bring out highlights.
Muted tones. Color by Marie Browning.

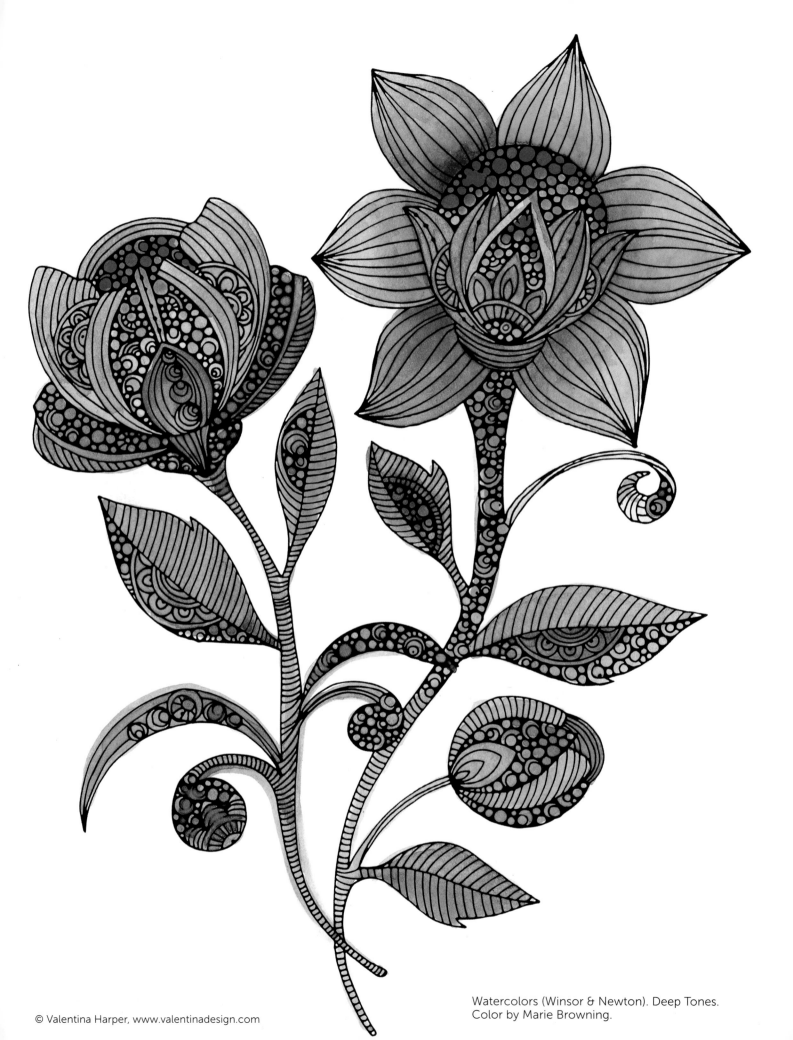

Watercolors (Winsor & Newton). Deep Tones.
Color by Marie Browning.

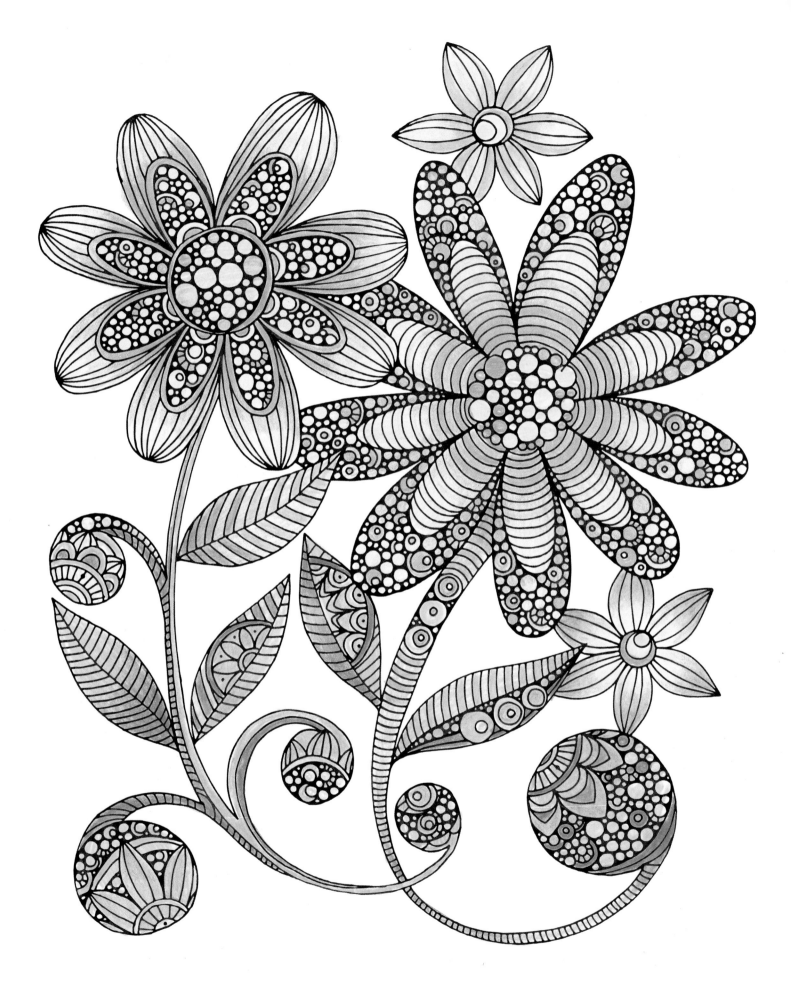

Irojiten Colored Pencils (Tombow). Pale Tones.
Color by Marie Browning.

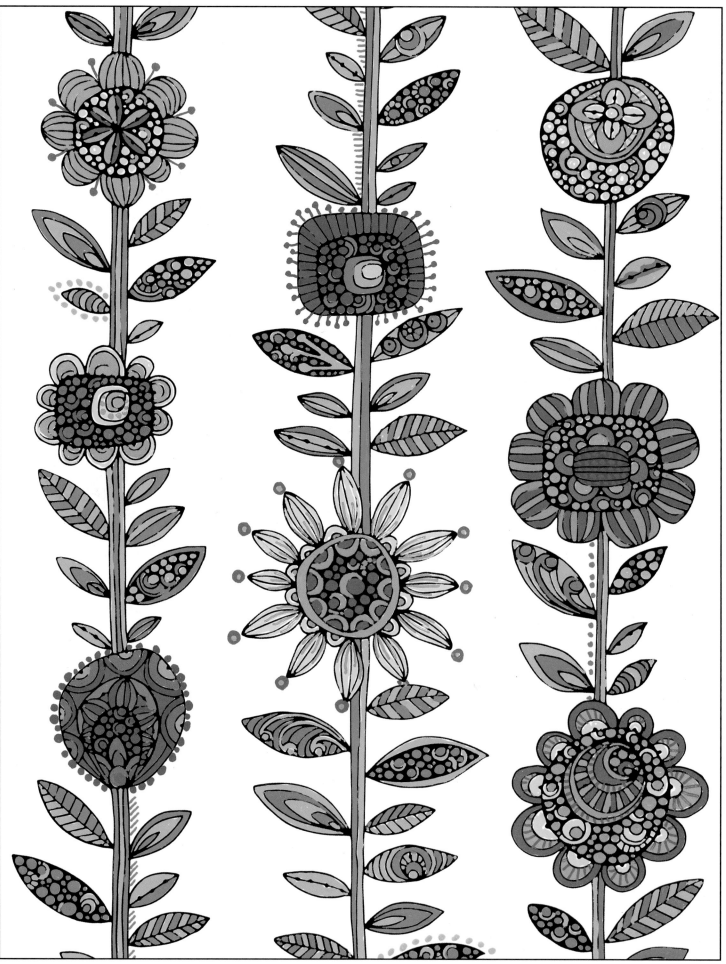

Moonlight Gel Pens (Sakura). Fluorescent Tones.
Color by Marie Browning.

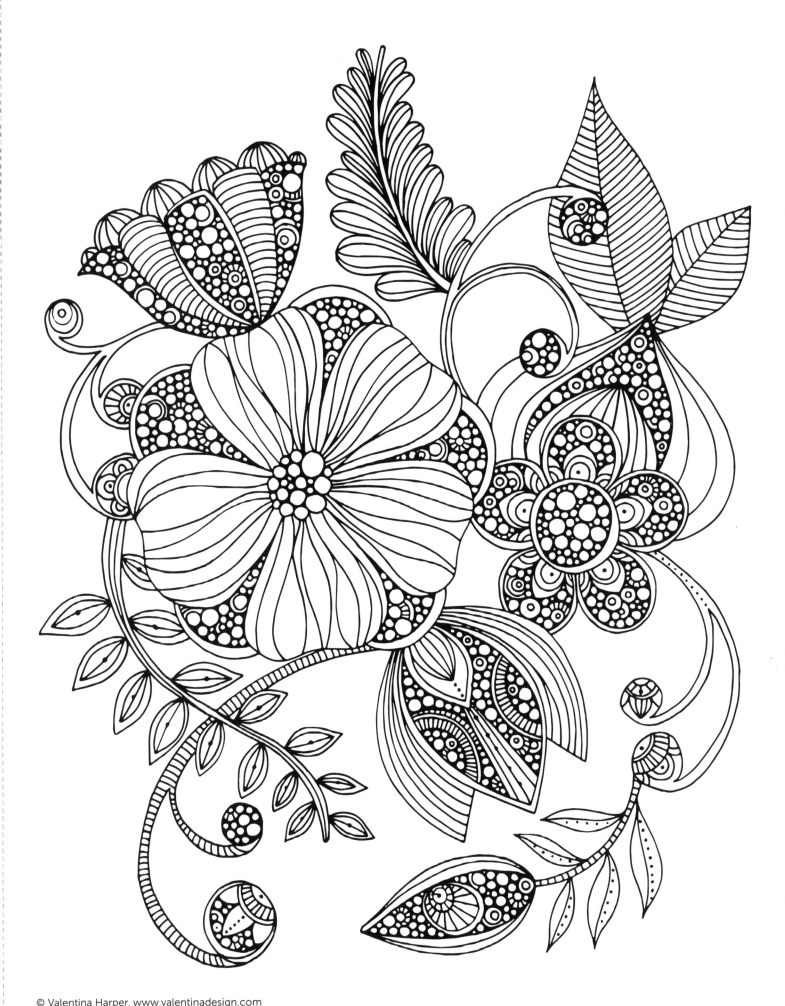

Let it grow, let it grow,
Let it blossom, let it flow.
In the sun, the rain, the snow,
Love is lovely, let it grow.

—Eric Clapton

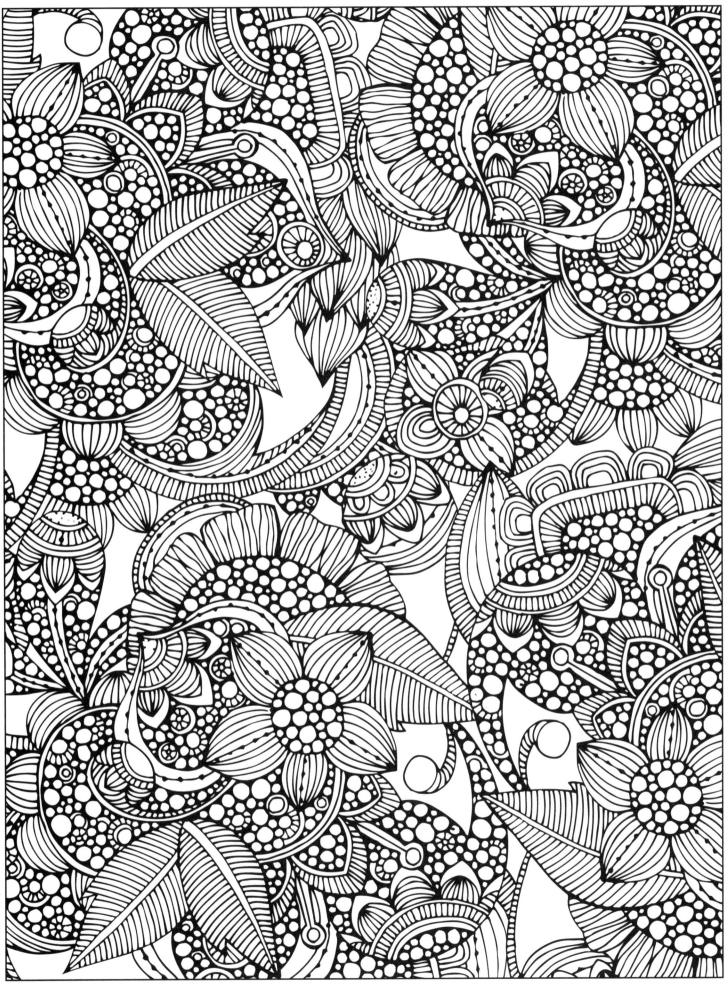

Your mind is a flower, your thoughts are the seeds,
the harvest can either be flowers or seeds.

—William Wordsworth

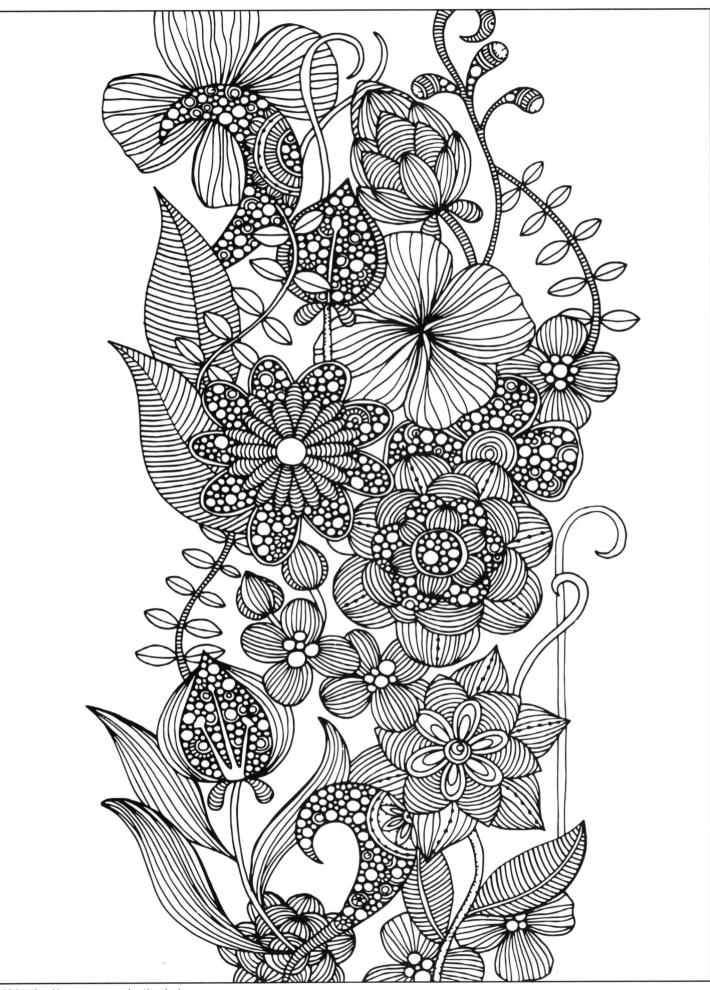

Create, grow, try and expand,
Dare, jump and just see where you land.

—Unknown

Asteria

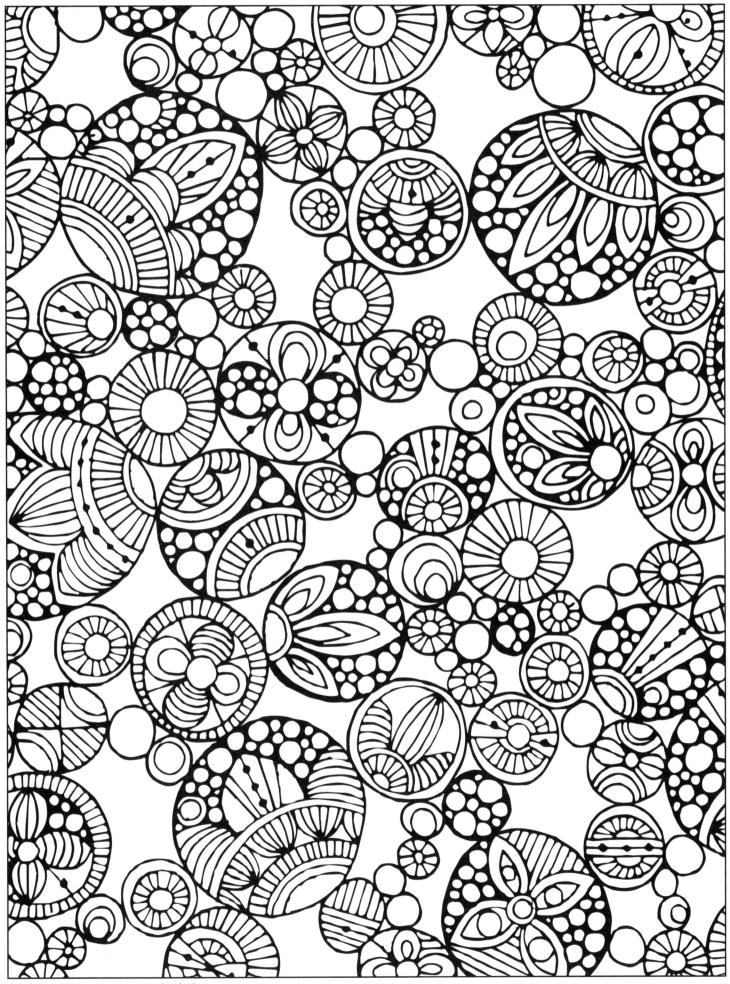

Turn your face to the sun
and the shadows will fall behind you.

—Maori Proverb

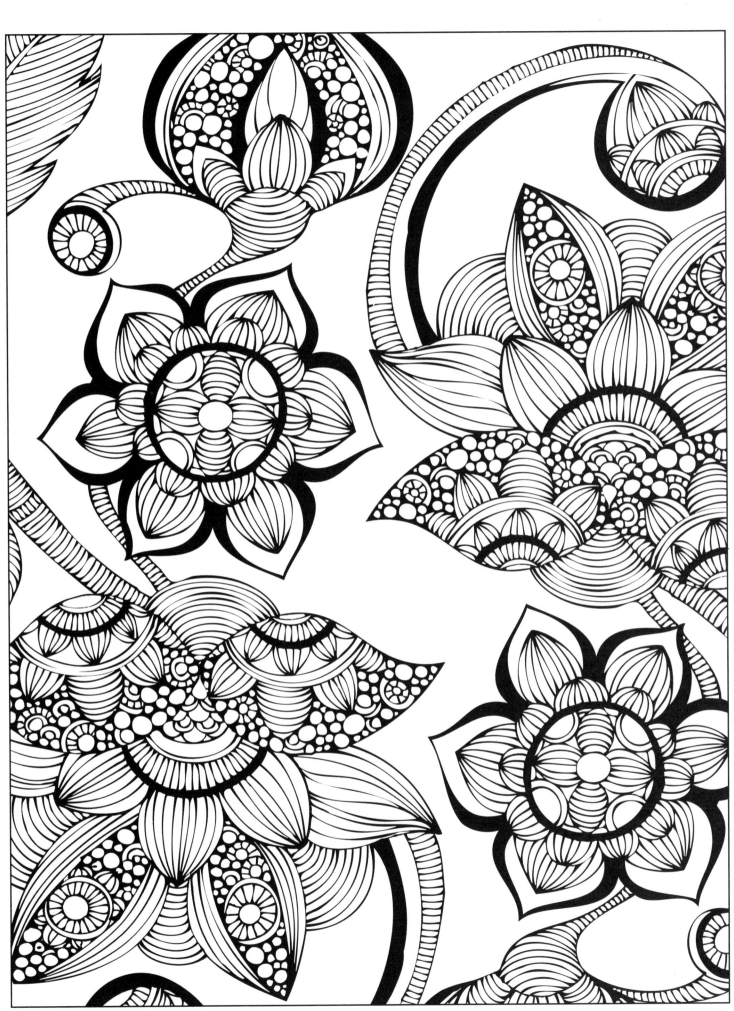

Those who bring sunshine to the lives of others
cannot keep it from themselves.

—J. M. Barrie

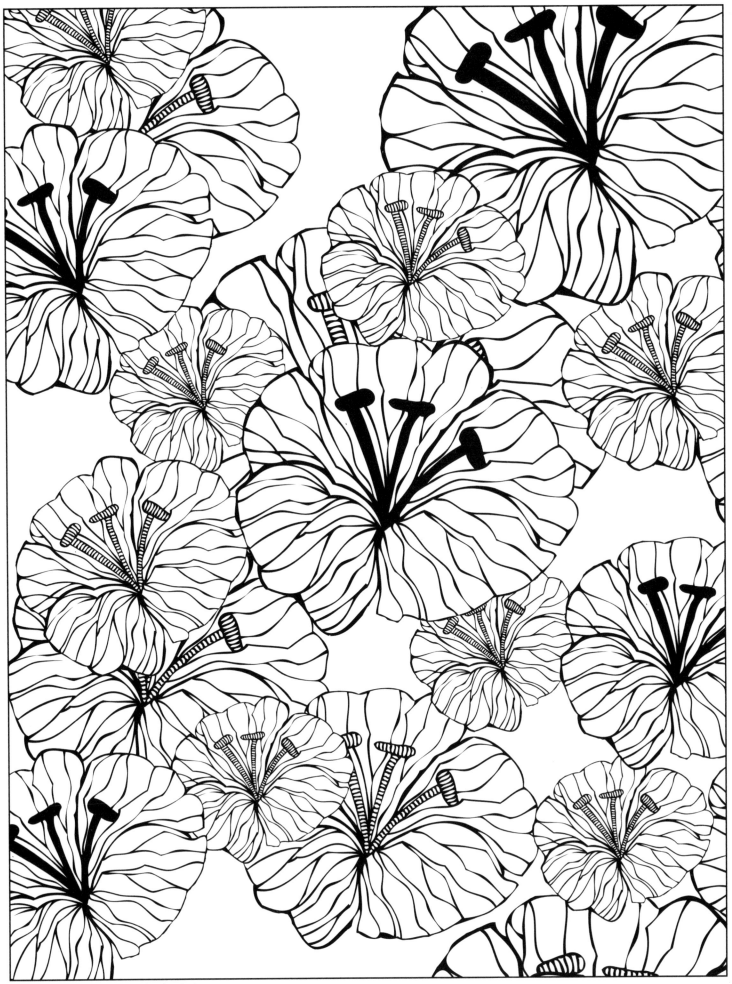

Pleasure is the flower that fades;
remembrance is the lasting perfume.

—Stanislaus Jean de Boufflers

Demeter

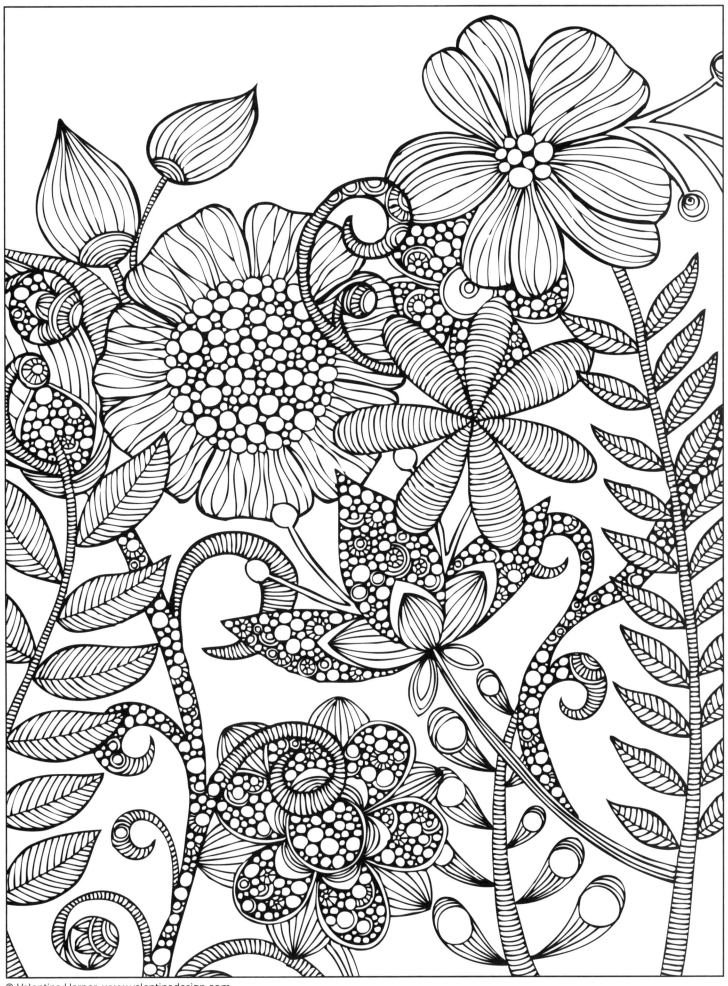

Nature does not hurry,
yet everything is accomplished.

—Lao Tzu

Eos

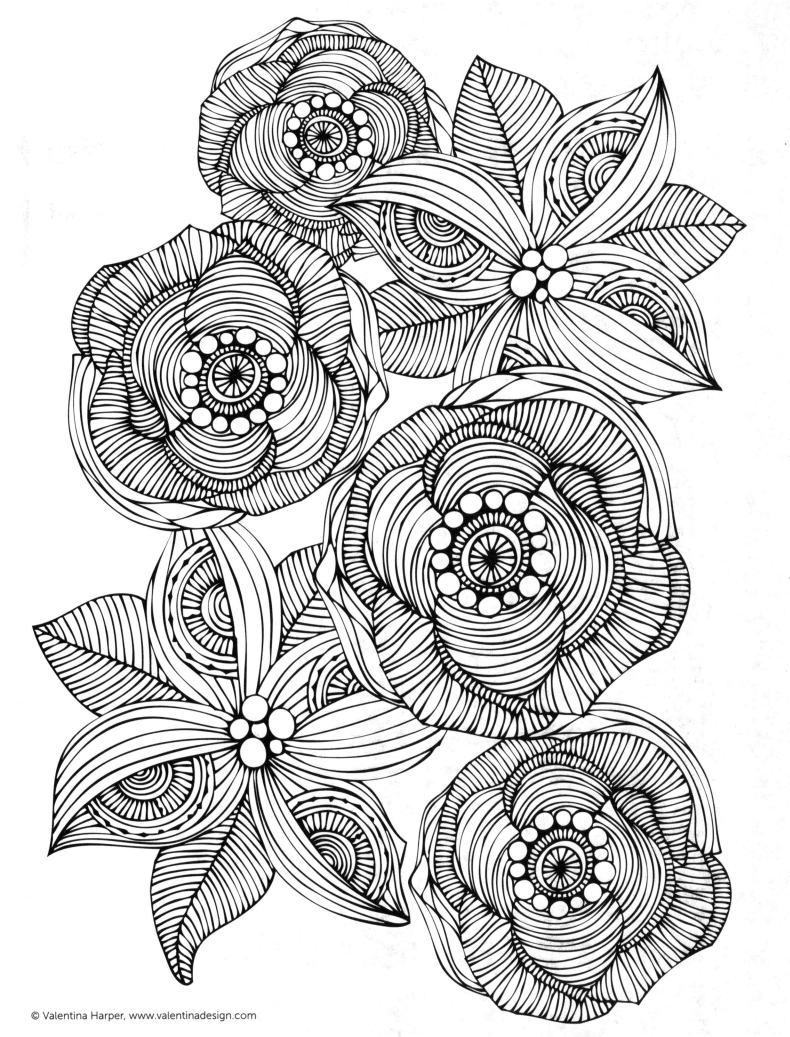

My heart is a flower
That blooms every hour
I believe in the power
Of love.

—Amos Lee

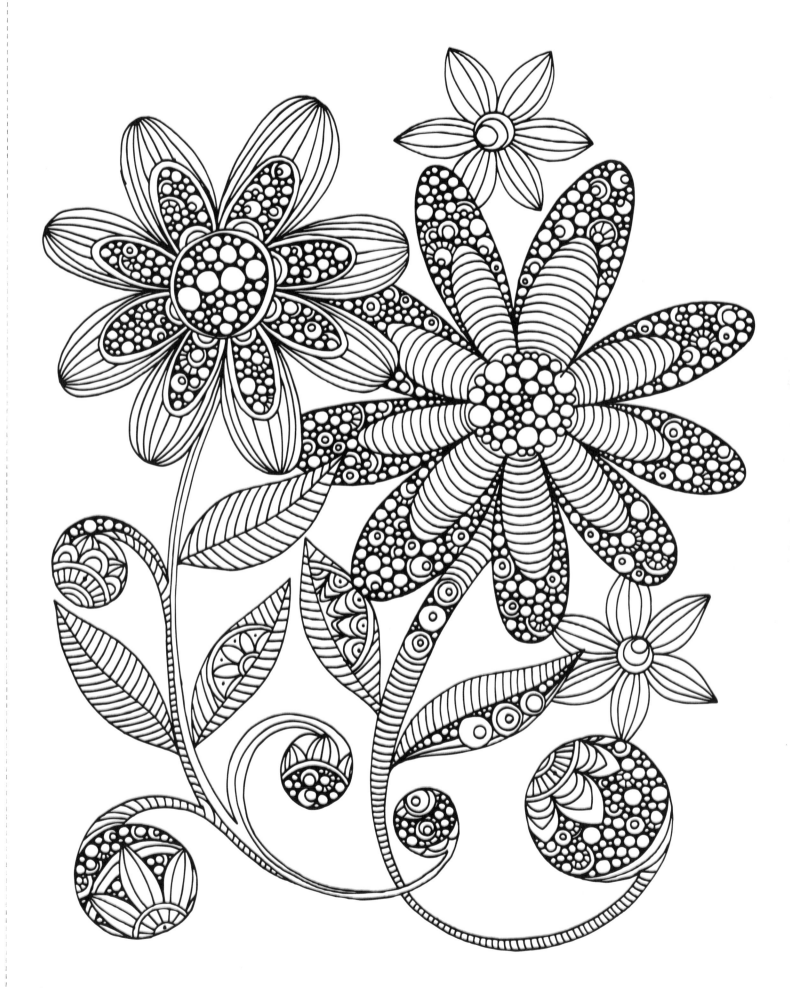

Everything grows better with love.

—Unknown

Eirene

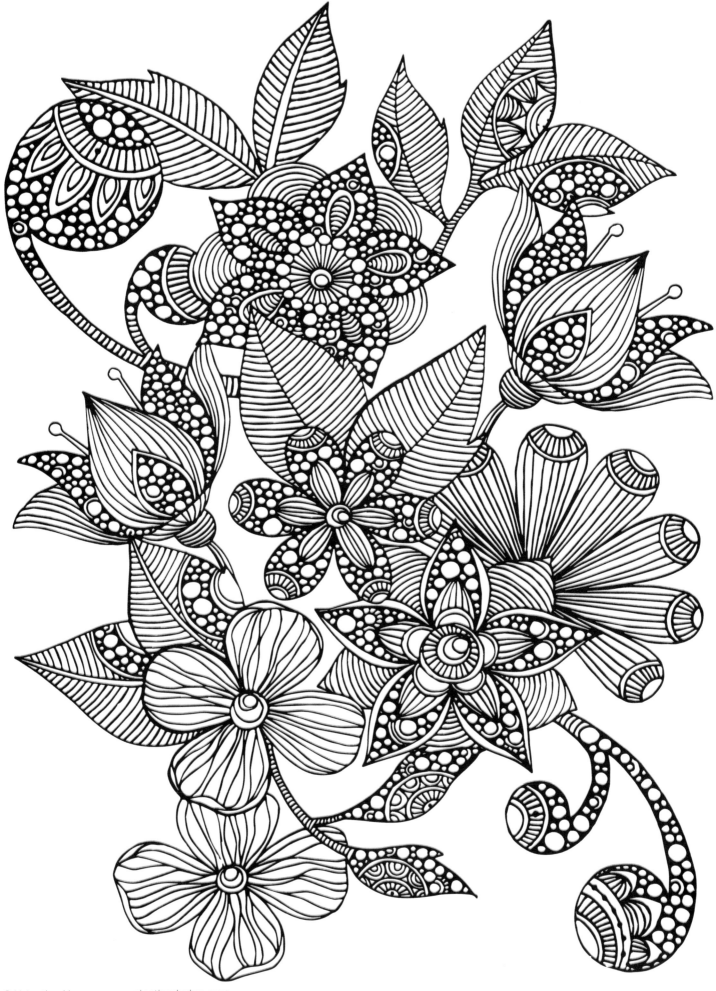

Friends are flowers in the garden of life.

—Proverb

Hebe

Every flower is a soul blossoming in nature.

—Gérard de Nerval

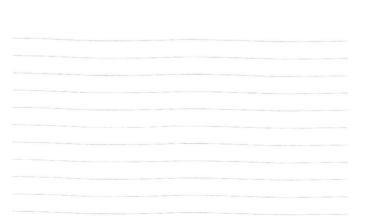

Hestia

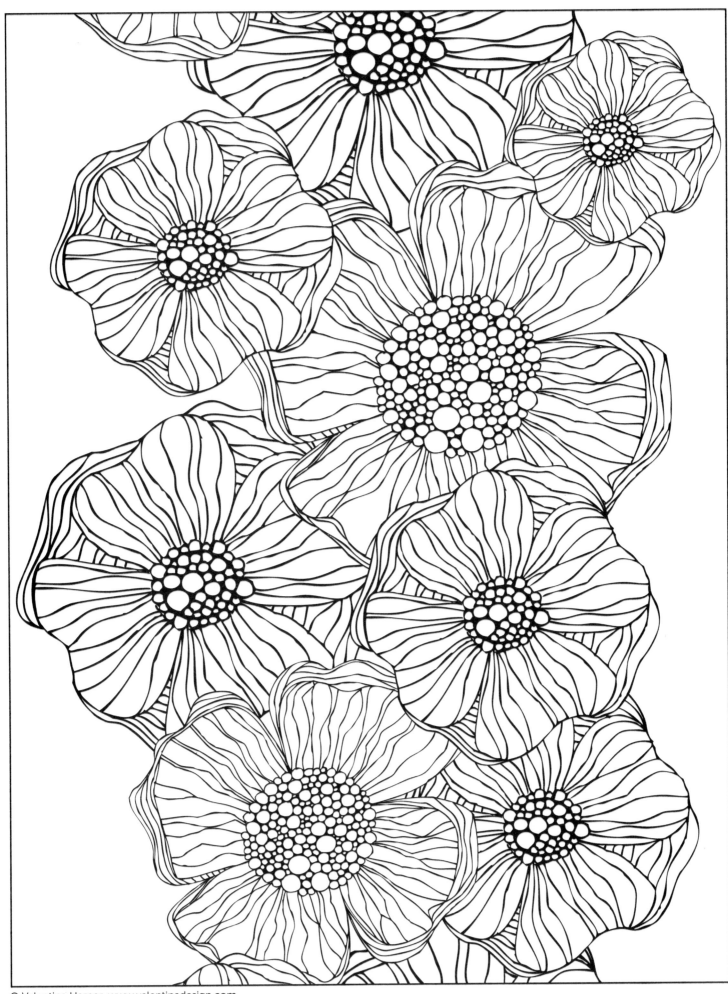

A flower cannot blossom without sunshine,
and man cannot live without love.

—Max Müller

Hygieia

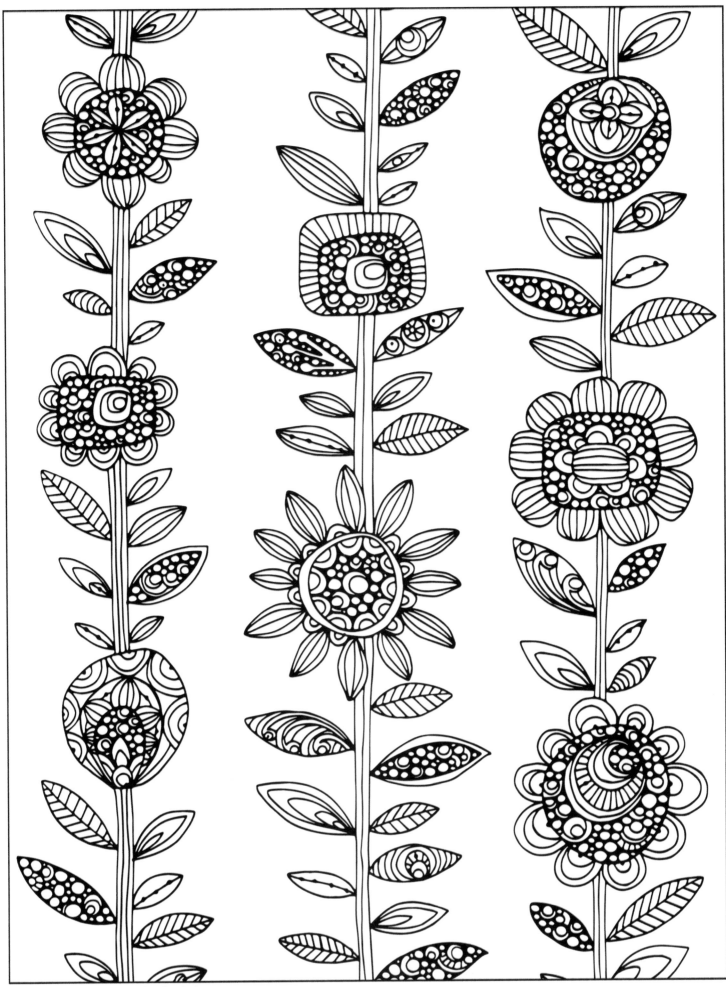

Bloom where you are planted.

—Unknown

Iris

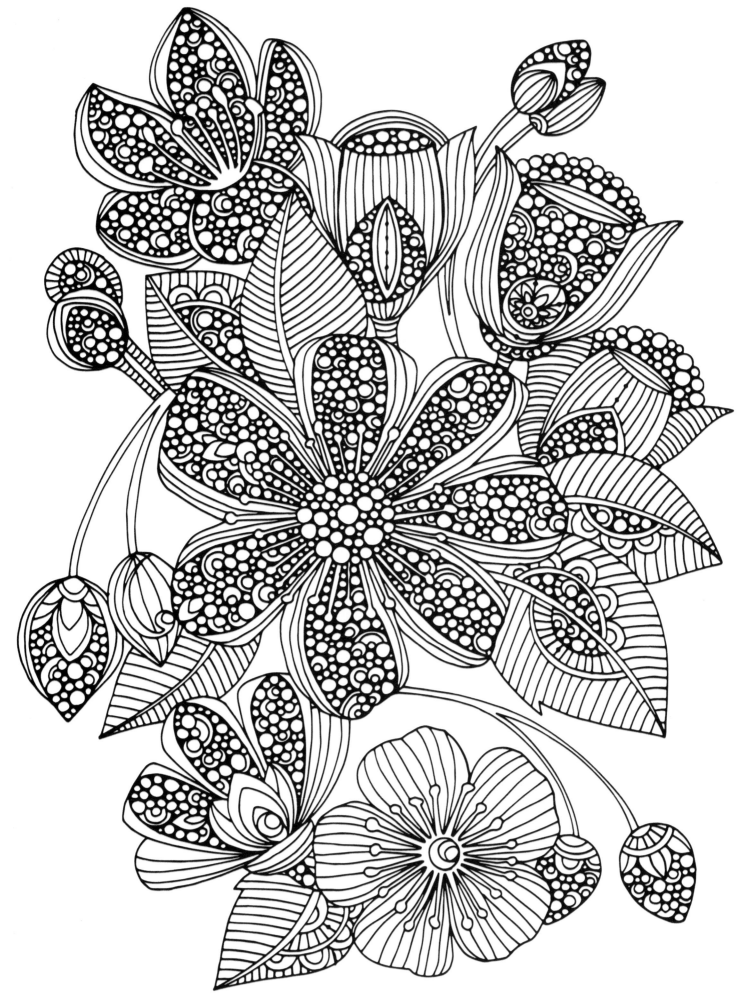

Children, marriages, and flower gardens
reflect the kind of care they get.

—H. Jackson Brown, Jr.

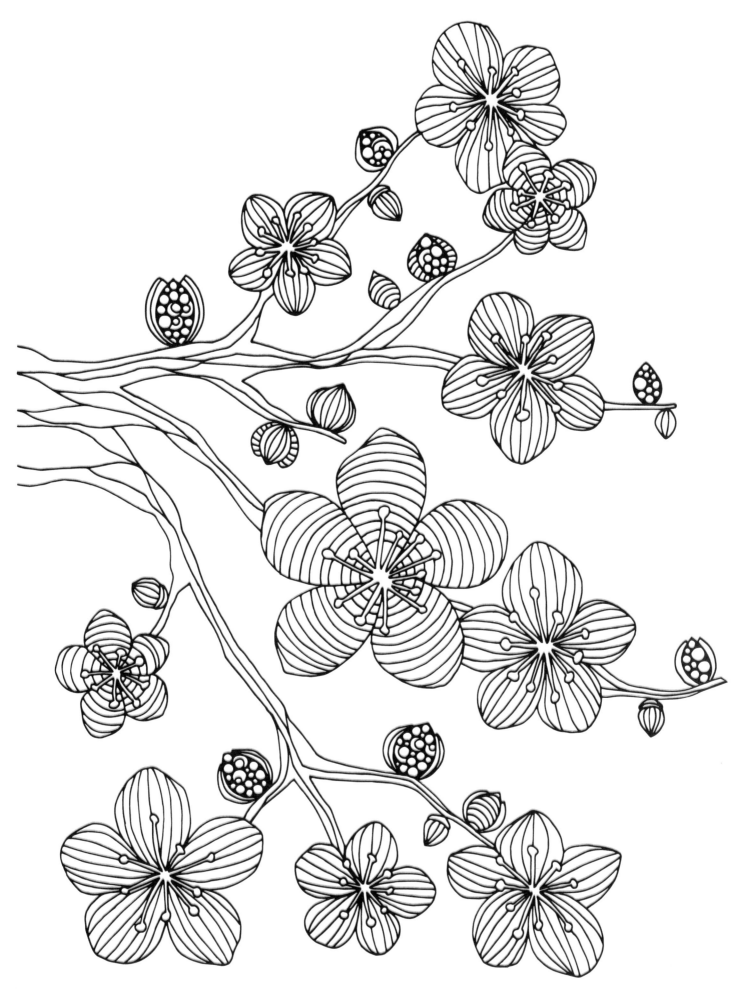

Where flowers bloom so does hope.

—Lady Bird Johnson

Maia

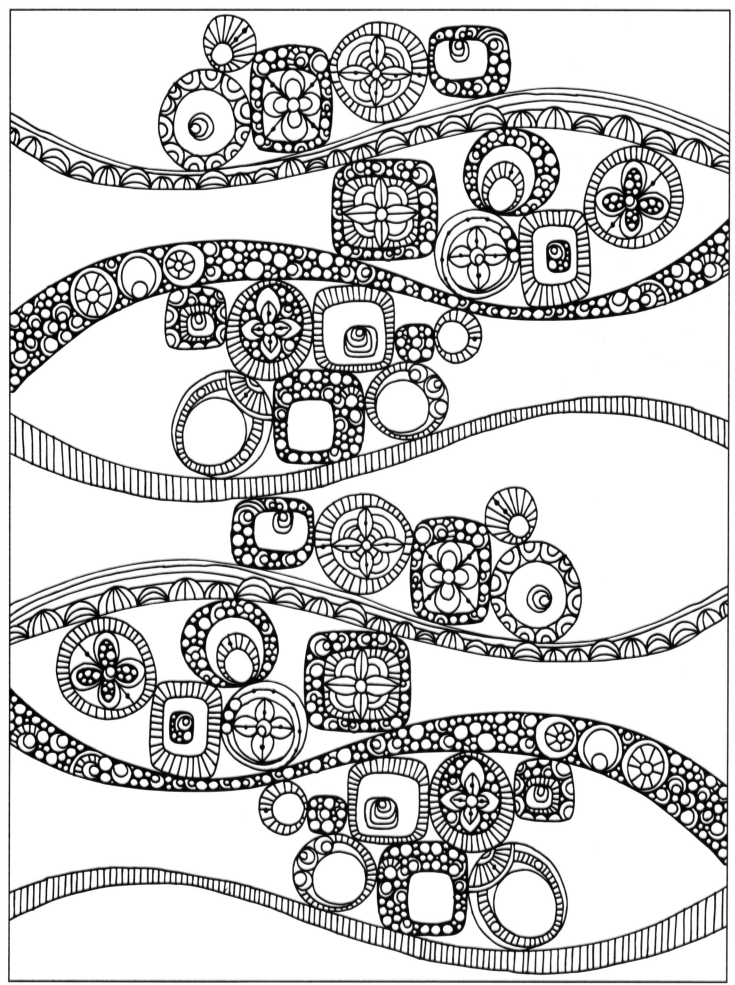

Every child is a different kind of flower,
and all together, they make this world
a beautiful garden.

—Unknown

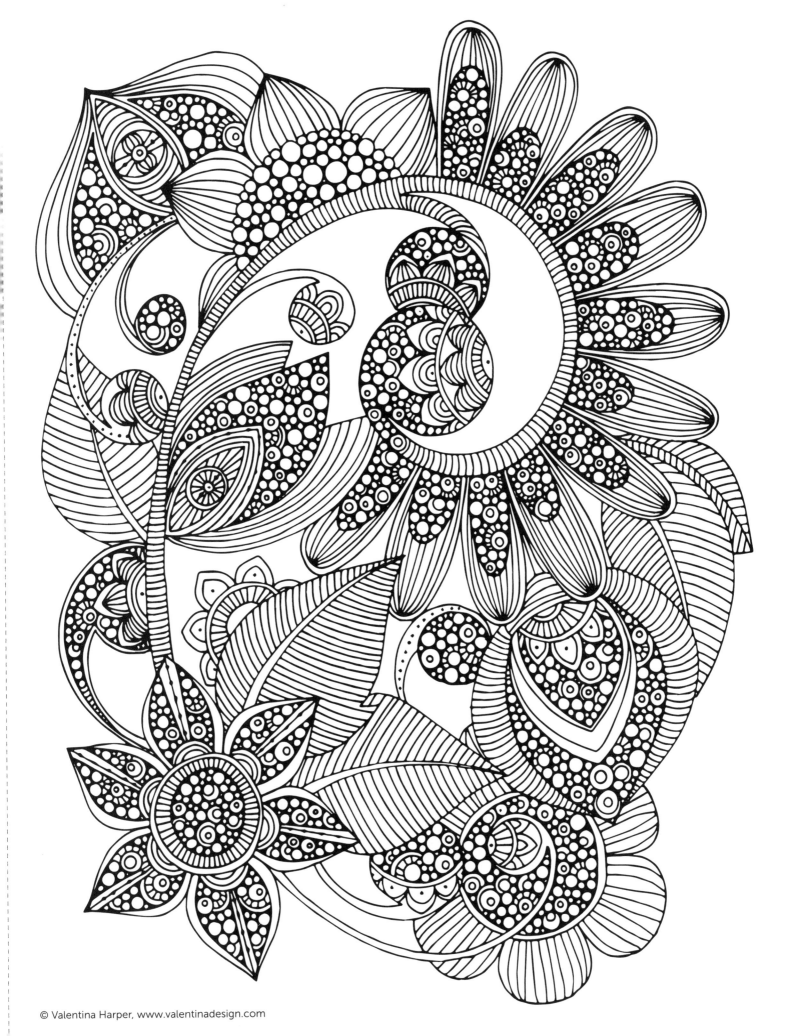

With freedom, books,
flowers, and the moon,
who could not be happy?

—Oscar Wilde

Nike

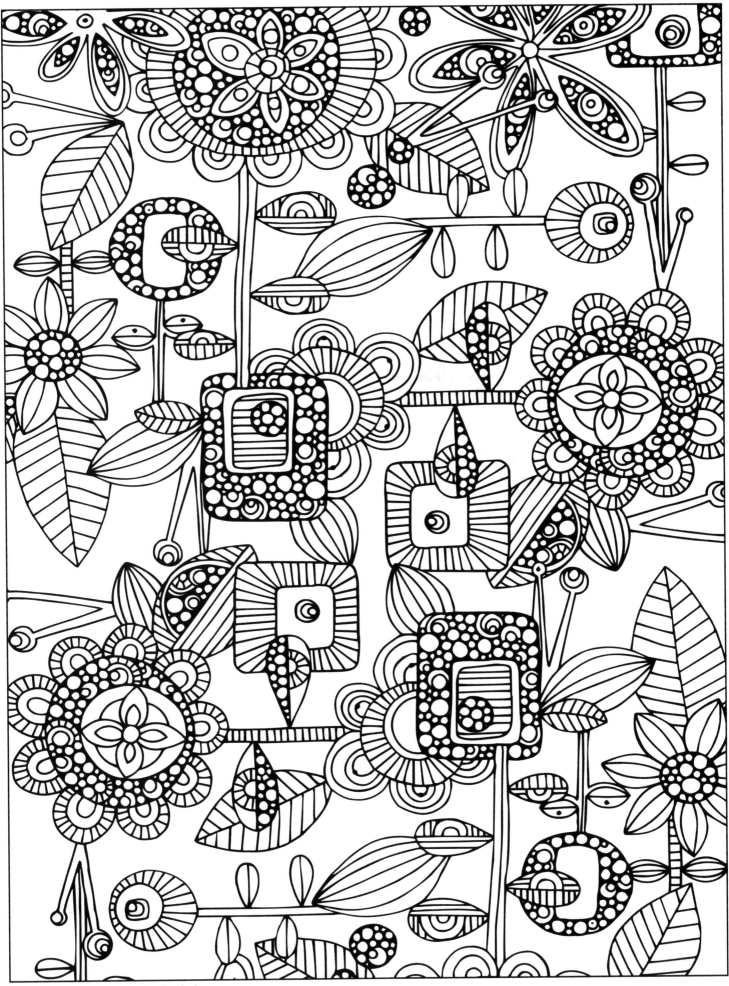

A friend is one who
overlooks your broken fence and
admires the flowers in your garden.

—Unknown

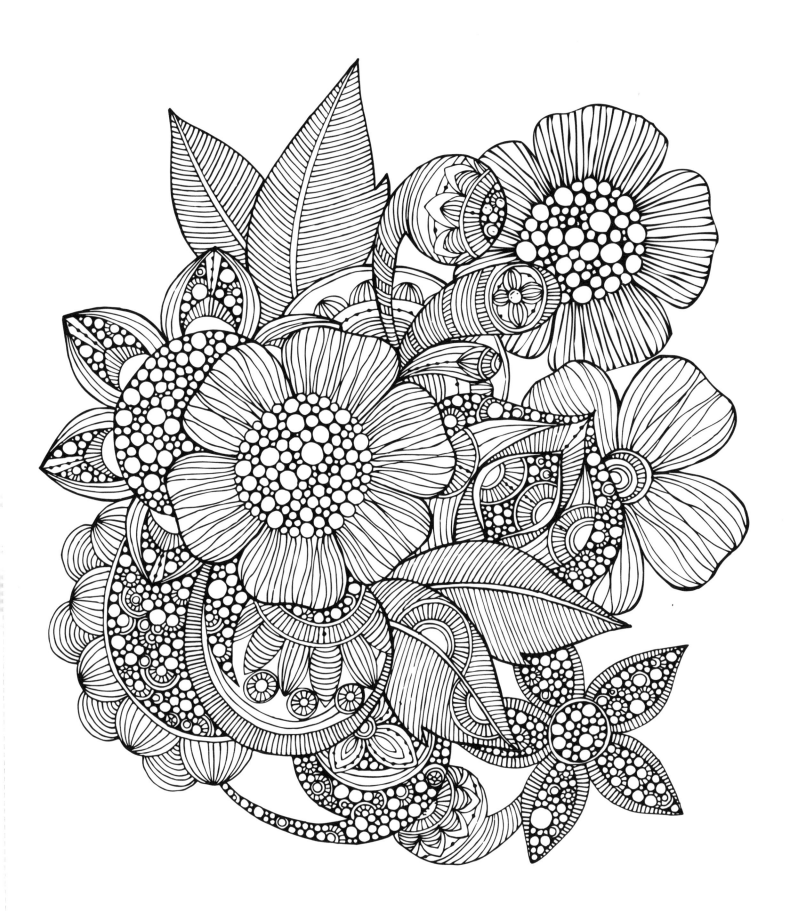

Earth laughs in flowers.

—Ralph Waldo Emerson

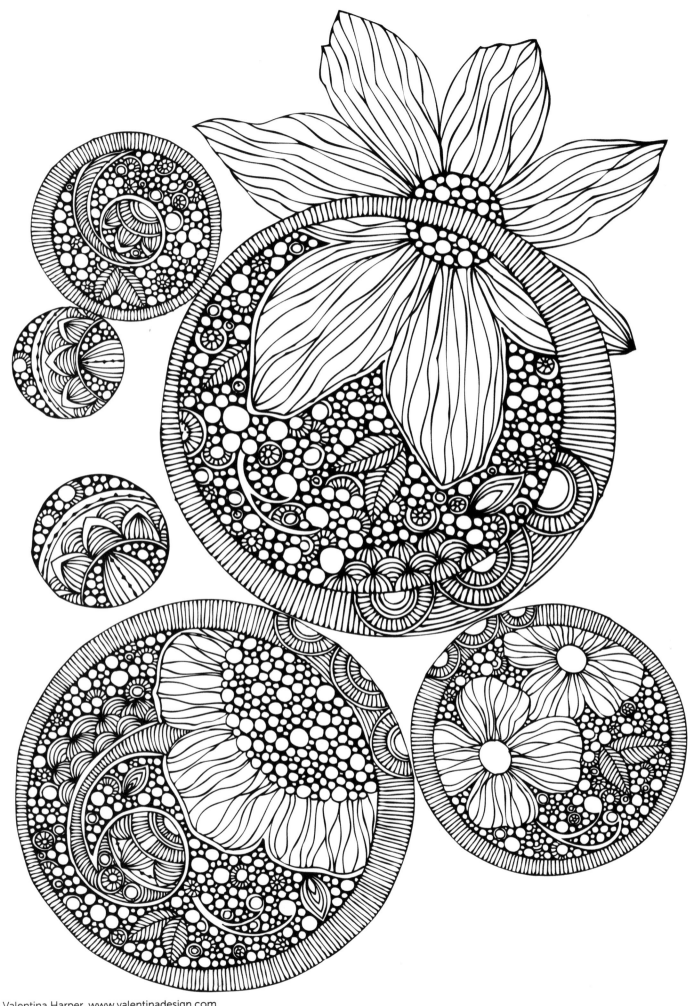

Happiness held is the seed;
Happiness shared is the flower.

—John Harrigan

Rhea

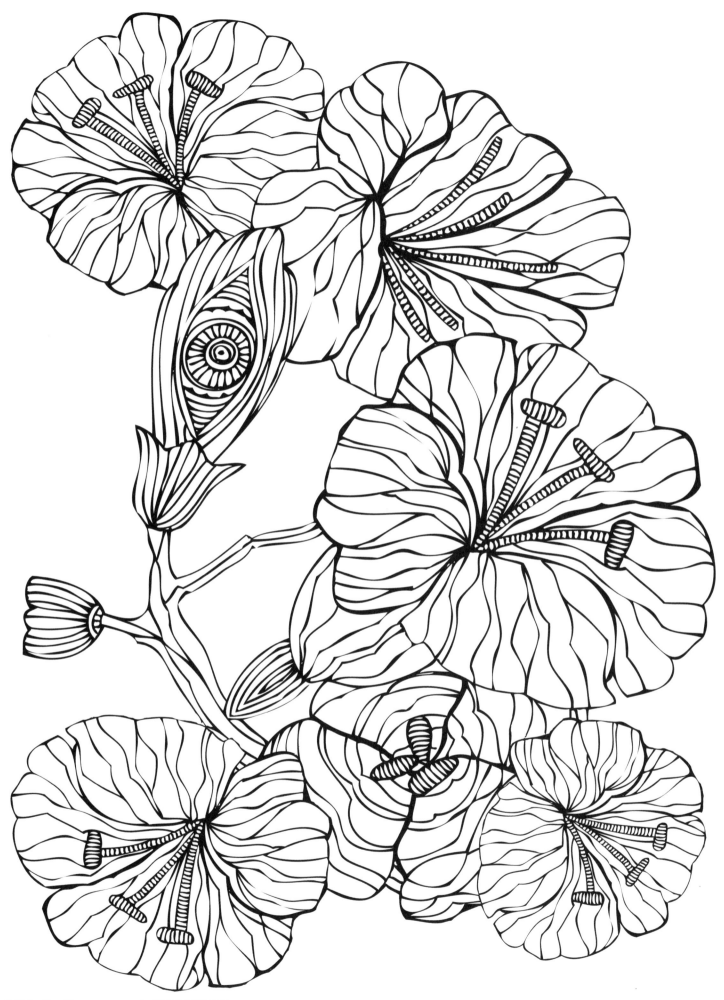

Flowers leave some of their fragrance
in the hand that bestows them.

—Chinese Proverb

Selene

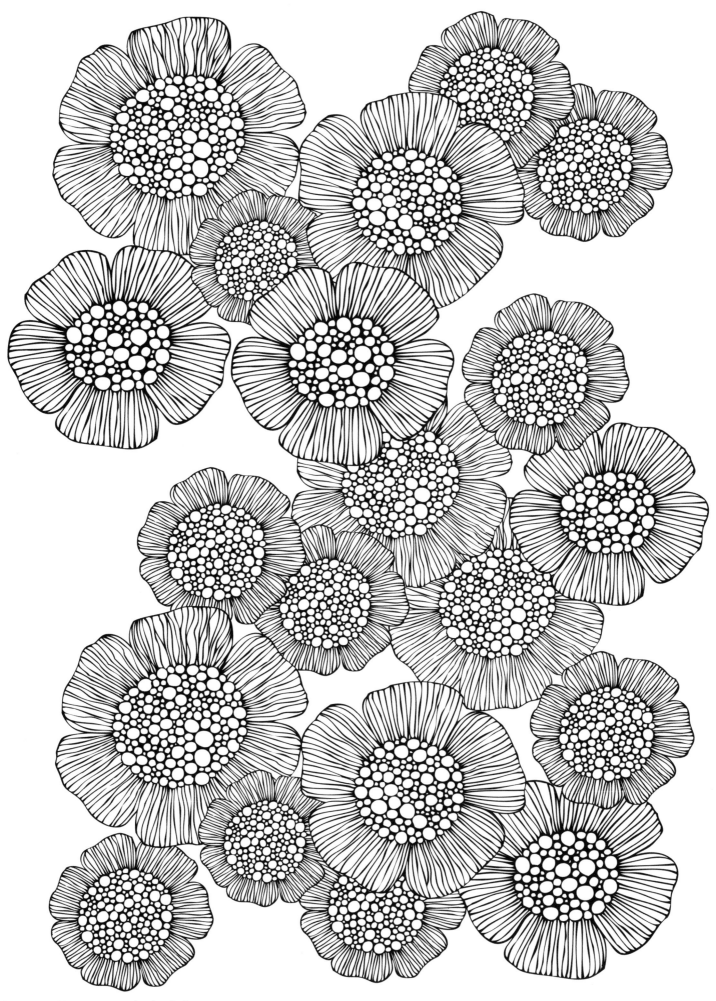

In joy or sadness
flowers are our constant friends.

—Kakuzō Okakura

Theia

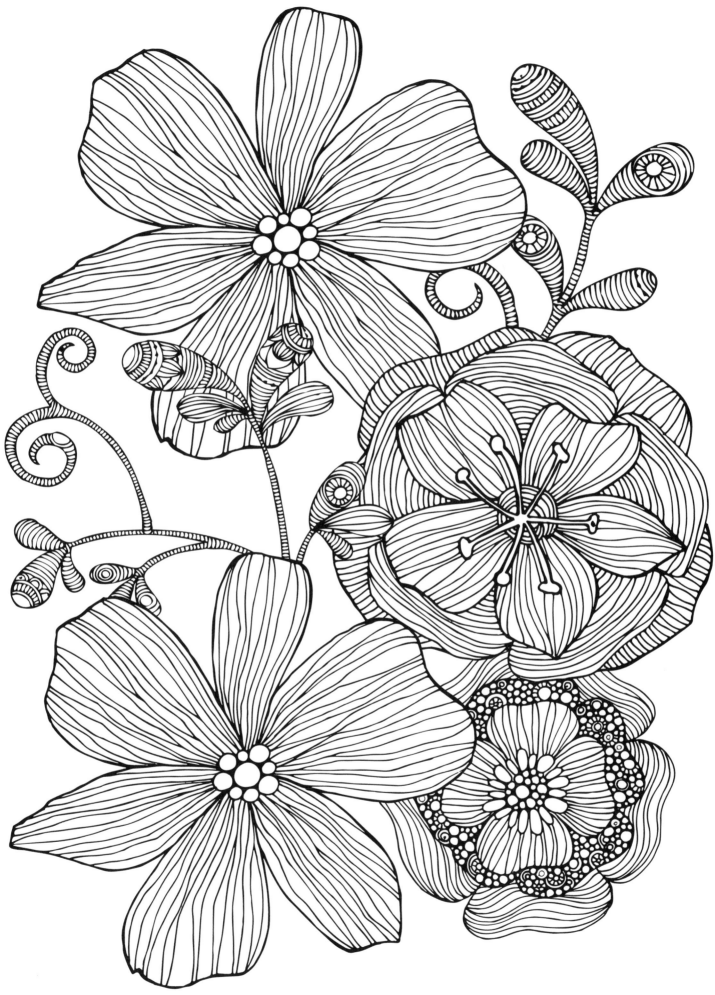

All the flowers of all the tomorrows
are in the seeds of today.

—Indian Proverb

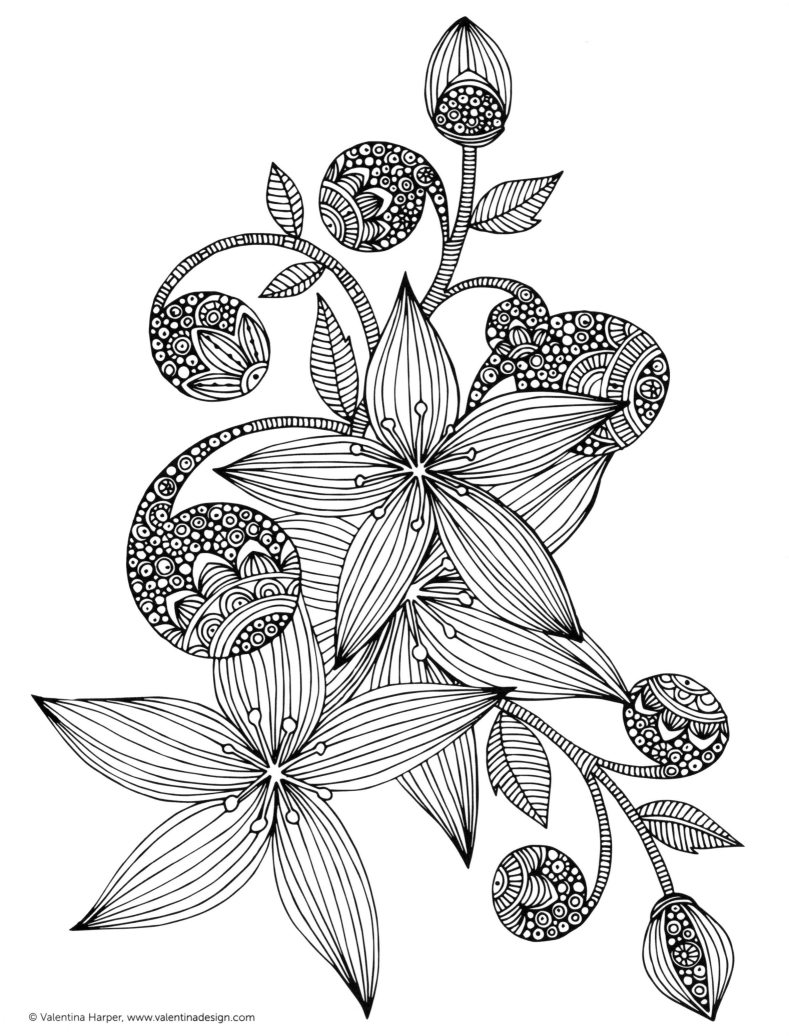

When you have only
two pennies left in the world,
buy a loaf of bread with one,
and a lily with the other.

—Chinese Proverb

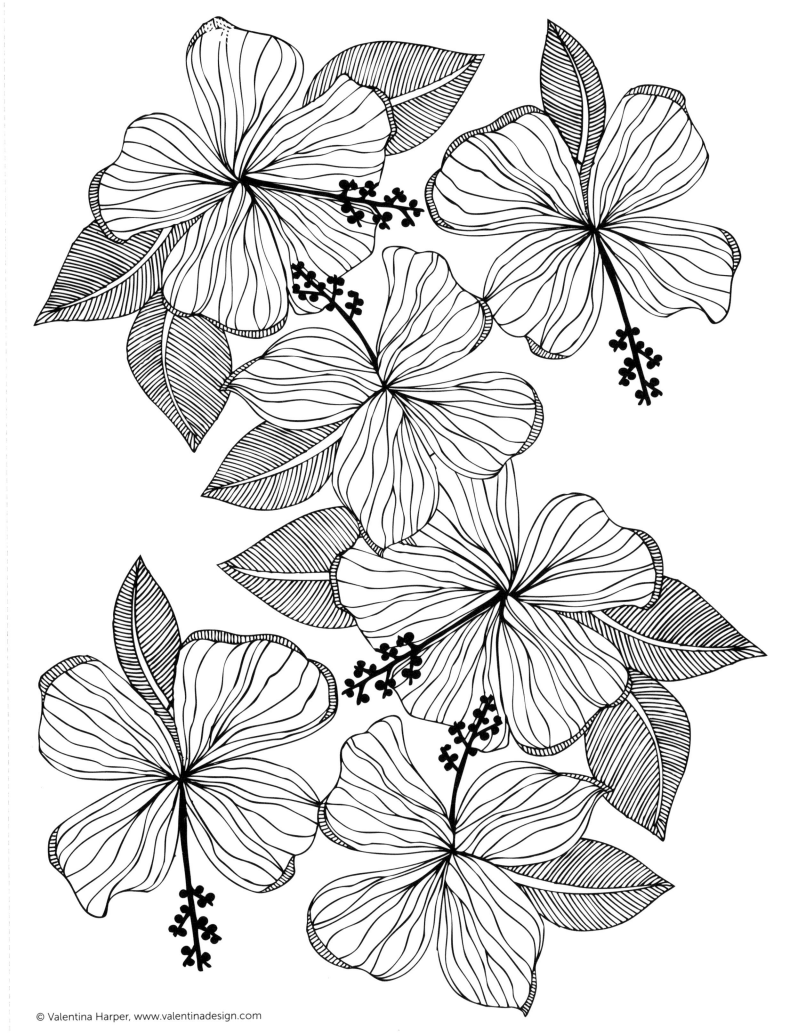

If we could see the miracle
of a single flower clearly,
our whole life would change.

—Buddha

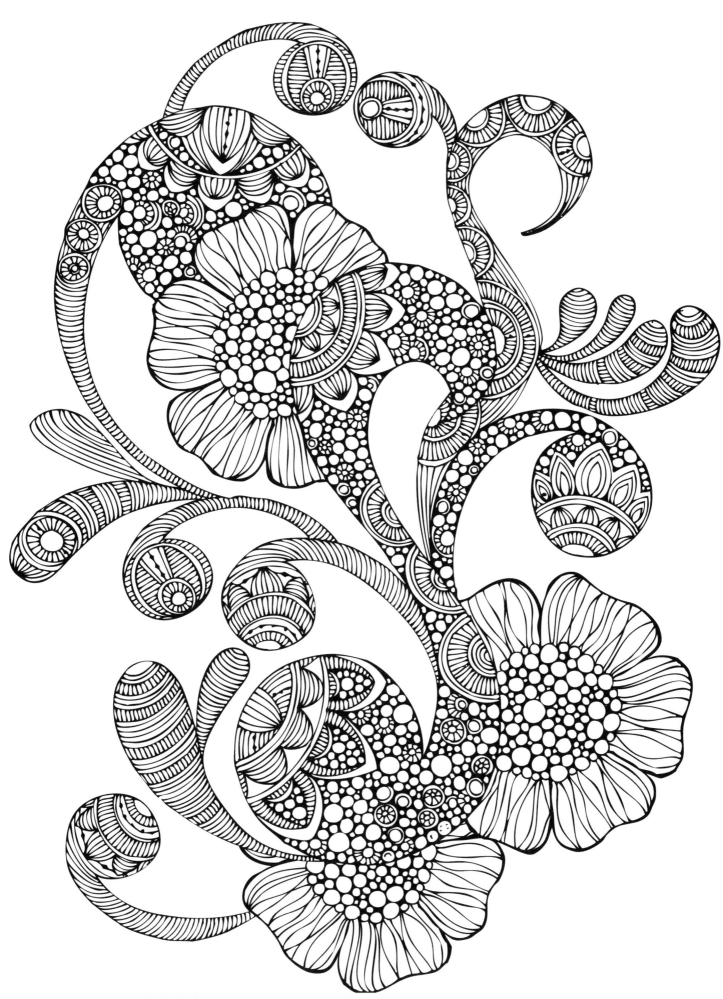

A weed is but an unloved flower.

—Ella Wheeler Wilcox

Lita

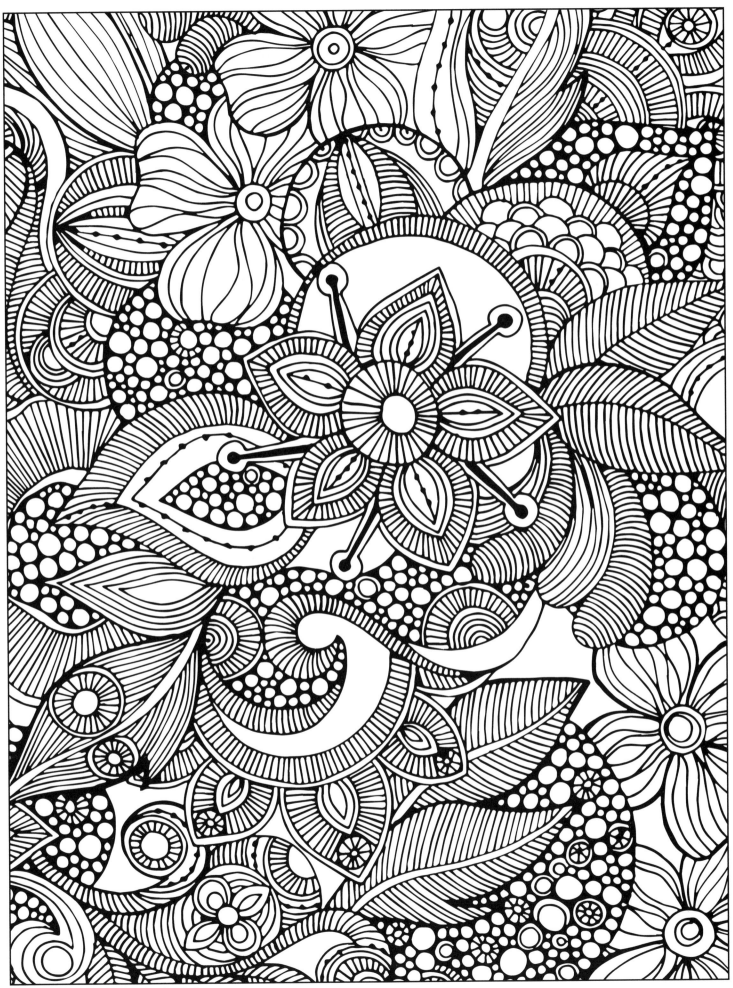

I must have flowers, always, and always.

—Claude Monet

———————————————
———————————————
———————————————
———————————————
———————————————
———————————————
———————————————
———————————————
———————————————
———————————————
———————————————
———————————————

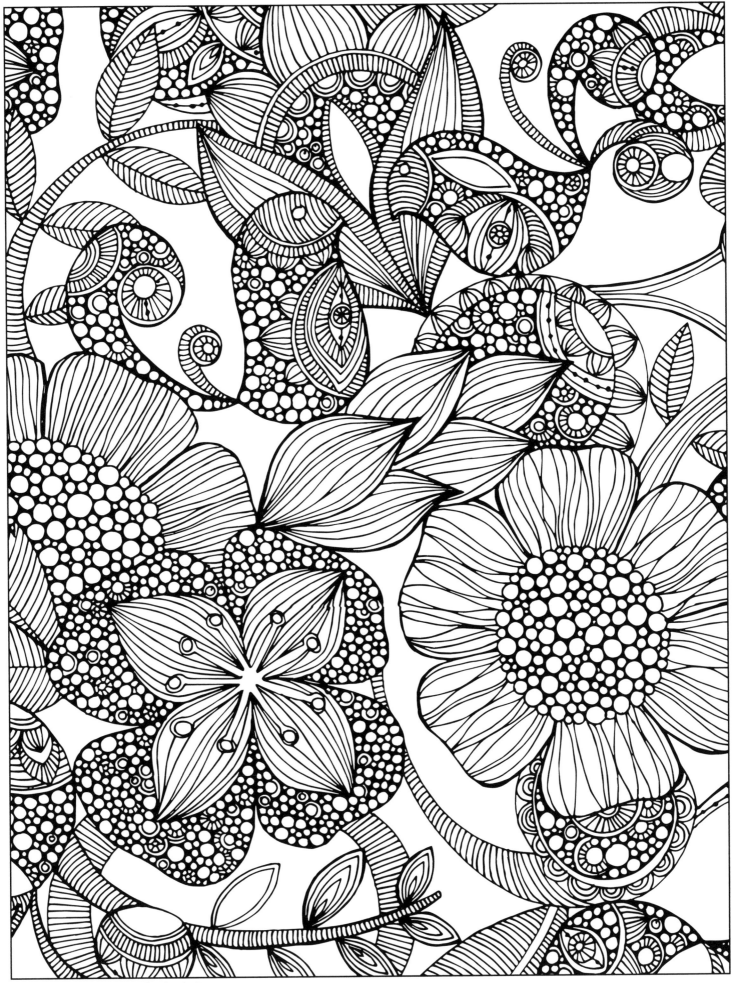

A weed is no more than a flower in disguise.

—James Russell Lowell

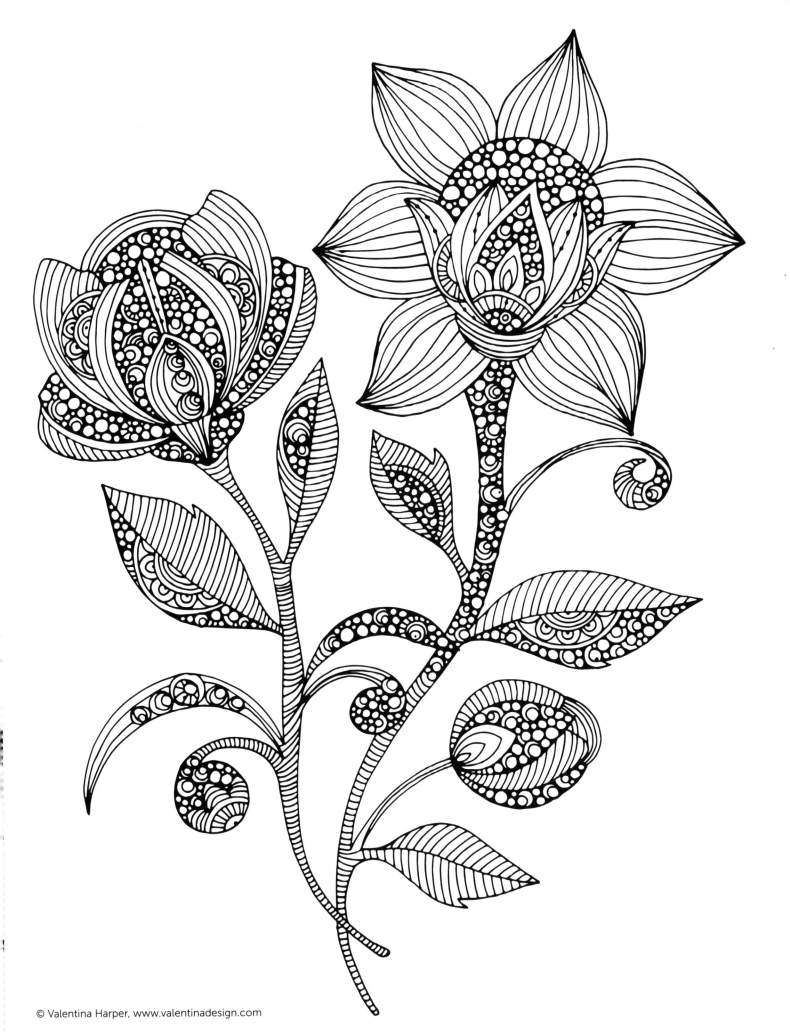

I'd rather have roses on my table
than diamonds on my neck.

—Emma Goldman

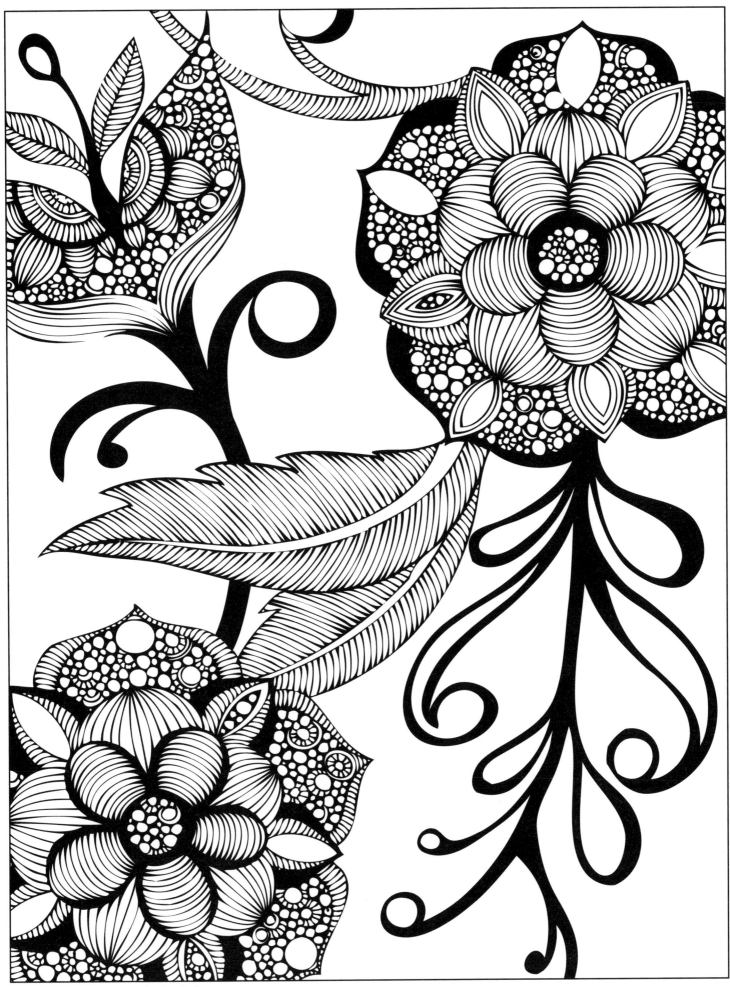

A rose by any other name
would smell as sweet.

—William Shakespeare